A Rug Hooking Book of Days

Featuring the

Fiber Art

of Polly Minick

A Publication of *Rug Hooking* magazine.

Designer
Cheryl Klinginsmith

Photographer
Bill Bishop

Rug Hooking

500 Vaughn Street

Harrisburg, PA 17110

(717) 234-5091

www.rughookingonline.com

~~~~~~~~~~

COVER: Stars with Star Border, 44" × 55";
#8-cut wool on burlap. Designed and hooked by
Polly Minick, 1995. Private collection.

# MEET THE ARTIST

COURTESY POLLY MINICK

*P*assionate is the one word that aptly describes Polly Minick. Whether she's discussing her home on St. Simons Island, Georgia, her Airedales, her supportive husband, or her grandchildren, Polly's passion shows through. But it's a safe bet to say that, outside of her family, Polly's greatest passion is hooking rugs.

*O*ne passion led to another for Polly. As she'd scout for antiques for her home she'd run across vintage hooked rugs, but found them in disrepair. Determined to have them in her home, she sought out a rug hooking class and learned to make them herself.

*W*ishing to have her rugs mimic those of a century ago, Polly studied old rugs and found common elements in their simple, primitive patterns: Early rug hookers drew inspiration from their love of home, pets, nature, and country. From the old rugs Polly also derived the muted color palette she works with. Like rug hookers of days gone by she frequently uses remnant wool from cast-off clothing and cuts it into 1/4" strips to pull through a burlap backing. (To learn more about the process, see page 63. For specific information about Polly's work, see her hooking hints at the end of each month. The captions under the photographs refer to a #8 cut of wool. In rug hooking, strips are usually cut with a special machine called a stripper, and the wheel number for a 1/4" cut is a #8.)

*S*ince 1986, when Polly began hooking, her rugs have met with praise from all corners. Thanks to stories about her work in such magazines as *Better Homes and Gardens*, *Country Home*, *Colonial Homes*, and *Rug Hooking*, Polly's rugs now command top dollar at an art gallery in New York City. She's regularly commissioned to hook rugs for clients all over the country. Her hooked pieces have also thrice won coveted recognition in the *Early American Homes* Directory of Traditional American Crafts.

*P*olly's passionate about promoting rug hooking, too. As the result of her exposure she has received countless letters from people wanting to learn to hook their own rugs. Working with *Rug Hooking* magazine to direct them to teachers has allowed her to further spread her enthusiasm for this fiber art.

*I*t's doubtful Polly's passion for hooked rugs will abate anytime soon. She plans a year's worth of projects during marathon dyeing sessions, constantly searches for wool, and eagerly engages in exhibits, commission assignments, and photo shoots for yet another article featuring her work.

*T*his book of days is a perpetual show of Polly's most representative work, and is a rare glimpse at several rugs now in private collections. For the many fans of Polly Minick's almost-antique rugs, *A Rug Hooking Book of Days* is a once-in-a-lifetime treat and a wonderful mix of practical advice and eye-catching art. May you find delight in its pages, room for reflections or notes on your own rug hooking, or the impetus you need to start your own hand-hooked rug.—*Patrice Crowley*

 Continued on page 63

# JANUARY

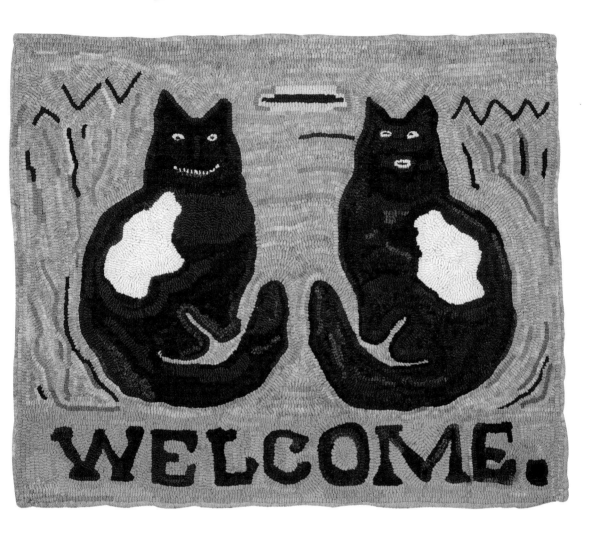

Welcome Cats, 34" × 28", #8-cut wool on burlap.
Designed and hooked by Polly Minick,
1995. Artist's private collection.
This design was modeled after an anonymous rug
dated 1885. Its wool came from the skirts of a
deceased friend, Millie Schembechler.

1

~~~~~~~~~~~~~~~~~~~~~~~~~

2

~~~~~~~~~~~~~~~~~~~~~~~~~

3

~~~~~~~~~~~~~~~~~~~~~~~~~

4

~~~~~~~~~~~~~~~~~~~~~~~~~

5

~~~~~~~~~~~~~~~~~~~~~~~~~

6

~~~~~~~~~~~~~~~~~~~~~~~~~

7

8

~~~~~~~~~~~~~~~~~~~~~~~~~

9

~~~~~~~~~~~~~~~~~~~~~~~~~

1O

~~~~~~~~~~~~~~~~~~~~~~~~~

11

~~~~~~~~~~~~~~~~~~~~~~~~~

12

~~~~~~~~~~~~~~~~~~~~~~~~~

13

~~~~~~~~~~~~~~~~~~~~~~~~~

14

# JANUARY

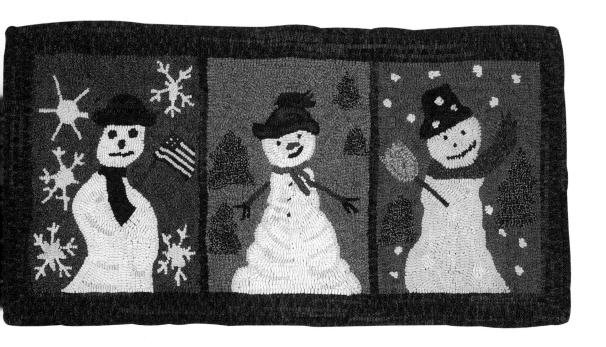

Melting snowmen, 34" x 17",
#8-cut wool on burlap. Designed by
Emma Lou Lais. Hooked by Polly
Minick, 1994. Private collection of
Shelby, Rachel, and Michael Thomas
Minick, Flower Mounds, Texas.
Copyright © Emma Lou Lais.

15

16

17

18

19

20

21

22

23

24

25

26

27

28

# JANUARY

**29**

**30**

**31**

## HOOKING HINTS FROM POLLY

I try to use as much vintage wool as possible. I am a frequent visitor to thrift shops because I like the look and feel of used wool. As a true rag picker, I go for the best—I try to use Pendleton brand wool as much as possible. You can always count on the quality of this wool. Most often it is checked, tweed, or plaid, and that works well with my dyeing methods.

# FEBRUARY

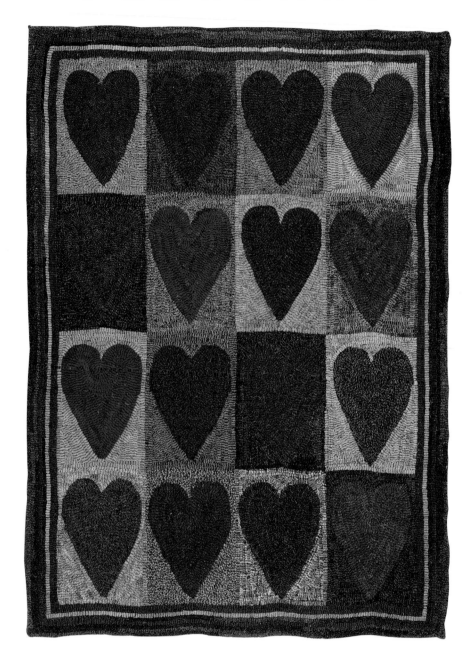

Hearts, 28" x 39", #8-cut wool on burlap.
Designed and hooked by Polly Minick,
1997. Private collection.

1

2

3

4

5

6

7

8

9

10

11

12

13

14 ♥

# FEBRUARY

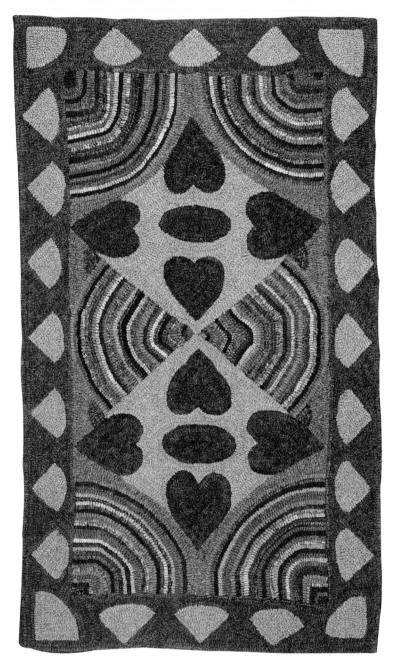

Hearts and Geometrics, 24" × 40", #8-cut wool on
burlap. Designed and hooked by Polly Minick,
1995. Private collection of Jeff and Linda Minick,
Flower Mounds, Texas.

15

16

17

18

19

20

21

22

23

24

25

26

27

28

# FEBRUARY

29

## HOOKING HINTS FROM POLLY

After obtaining used wool, I wash it immediately. Then I take

it apart carefully and get all the yardage I can from it.

I wash the wool a second time before storing

it in containers.

# MARCH

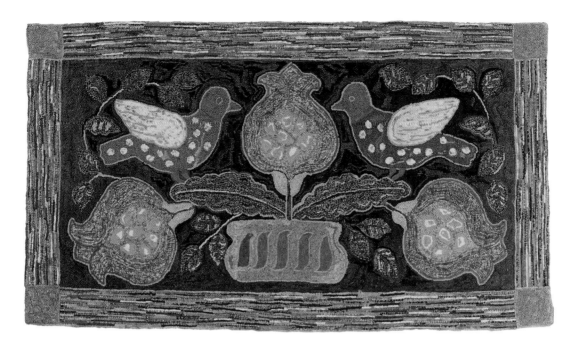

Birds and Pomegranates,
65" x 36", #8-cut wool on burlap.
Designed by Edyth O'Neill. Hooked
by Polly Minick,
1987. Private collection.
The large flowers and birds
attracted Polly to this pattern.
Copyright © 1982, Edyth O'Neill.

1

2

3

4

5

6

7

8

9

10

11

12

13

14

# MARCH

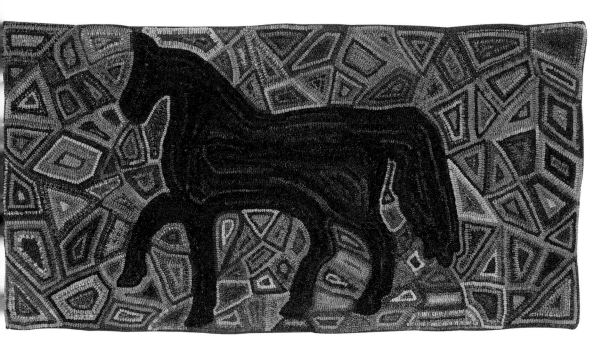

Horse on Blue Geometric Ground,
44" × 26", #8-cut wool on burlap.
Designed and hooked by Polly Minick,
1996. Private collection of John and
Sharon Minick, Annapolis, Maryland.
In 1989 Polly had hooked a smaller
version of this pattern, then returned
to the intriguing juxtaposition of
simple horse and complex
background for this piece.

15

_____

16

_____

17

_____

18

_____

19

_____

20

_____

21

22

_____

23

_____

24

_____

25

_____

26

_____

27

_____

28

# MARCH

29

31

30

## HOOKING HINTS FROM POLLY

I continually check with woolen mills to see what they have
and buy directly from them, especially if they have a light
background tweed or check. I hook so many rugs each year
that I don't always have enough vintage wool to use, so it
pays to keep in touch with the mills. They are good about
sending out stock samples.

# APRIL

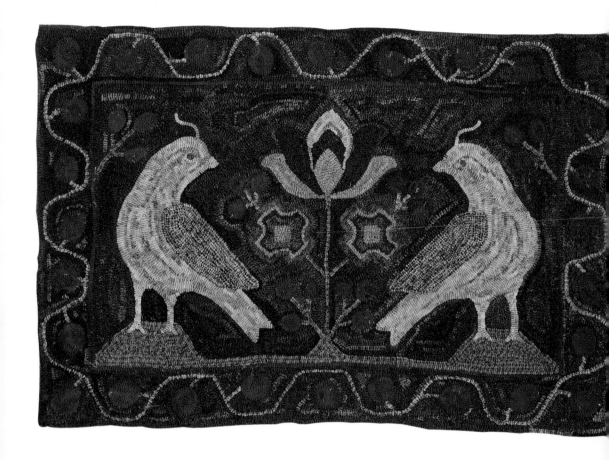

Ohio Coverlet, 40" x 28", #8-cut wool on burlap.
Designed by Edyth O'Neill. Hooked by Polly Minick,
1996. Private collection.
The bright blue birds and tulip are reminiscent
of Pennsylvania Dutch folk art.
Copyright © 1996, Edyth O'Neill.

1

2

3

4

5

6

7

8

9

10

11

12

13

14

# APRIL

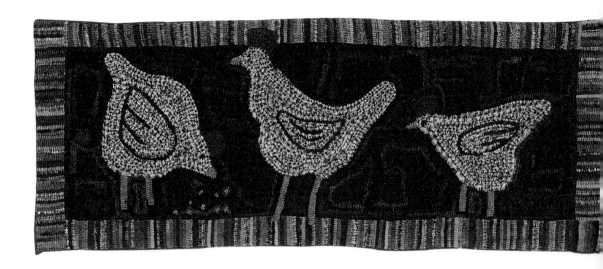

Three Chickens, 48" x 19", #8-cut wool on burlap. Designed by Fran Bossel. Hooked by Polly Minick, 1997. Artist's private collection. Fran, a friend of Polly's, kindly included corn for these three hens to peck. Note the brightly striped border and the use of several black and cream checks in the chickens.

15

16

17

18

19

20

21

22

23

24

25

26

27

28

| 29 | 30 |

## HOOKING HINTS FROM POLLY

Store your clean wool by color, and then when you are ready to
dye, it will be easier for you to select what you need. You will
soon learn what colors of wool work best with each dye formula
to get your desired color.

# MAY

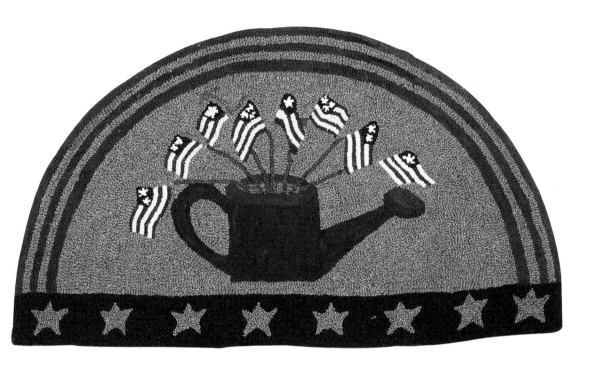

Flags in Watering Can, 36" x 21", #8-cut wool on burlap. Designed and hooked by Polly Minick, 1995. Private collection of Major and Mrs. James Minick, USMC, San Clemente, California. A half-round rug was often used before a hearth in early times. This imaginative rug hangs in a bedroom in the home of Polly's son.

1

2

3

4

5

6

7

8

9

10

11

12

13

14

# MAY

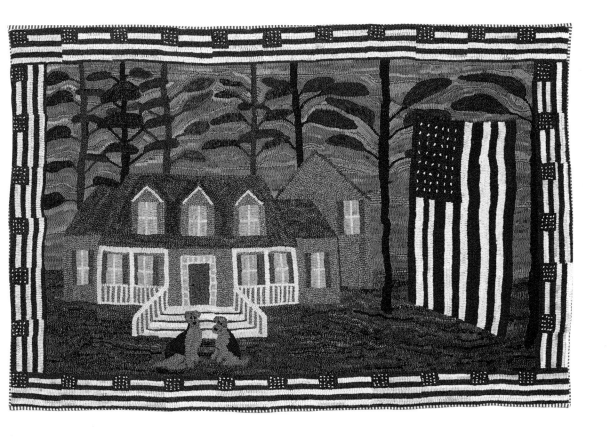

Memorial Day on St. Simons, 54" × 36", #8-cut
wool on burlap. Designed and hooked by
Polly Minick, 1997. Artist's private collection.
Polly's concept for this re-creation of her Georgia
home was drawn for her by noted rug hooker and
designer Barbara Brown, of Kennebunkport, Maine.
Polly's Airedales, Dixie and Pepper, rest by the
porch steps.

15

16

17

18

19

20

21

22

23

24

25

26

27

28

# MAY

29

31

~~~~~~~~~~~~~~~~~~~~~~~~~~~

30

HOOKING HINTS FROM POLLY

I use both PRO Chemical & Dye and Cushing brand dyes. I
started out on Cushing dyes and have a good grasp of the col-
ors. Then I started working with Maryanne Lincoln and learned
about PRO Chem dyes. The book *Antique Colours for Primitive
Rugs* by Barbara Carroll and Emma Lou Lais (W. Cushing &
Company, 1996), is just wonderful if you use Cushing dyes.

JUNE

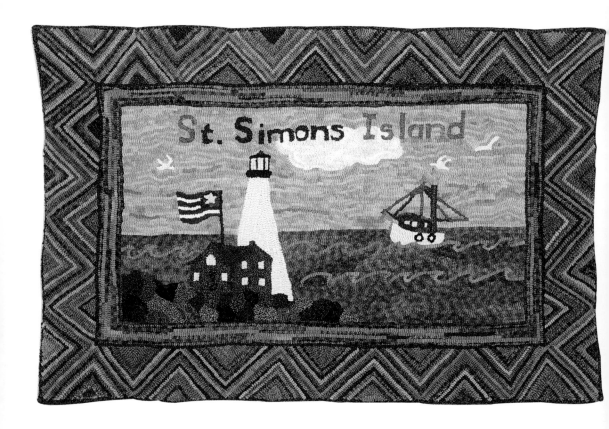

St. Simons Island Scene, 42" × 32", #8-cut wool
on burlap. Designed and hooked by Polly Minick,
1995. Private collection.

1

2

3

4

5

6

7

8

9

10

11

12

13

14

JUNE

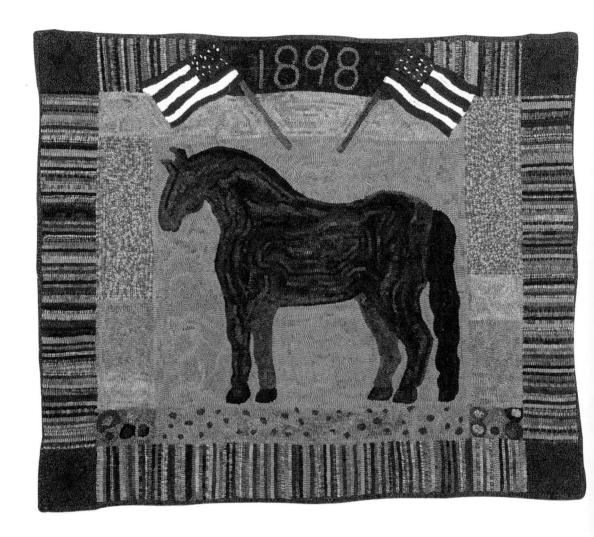

Horse with Crossed Flags in Border, 44" x 36", #8-cut wool
on burlap. Designed and hooked by Polly Minick,
1993. Private collection
of Paul and Diane Kelly, Dorset, Vermont.

15

16

17

18

19

20

21

22

23

24

25

26

27

28

JUNE

| 29 | 30 |

HOOKING HINTS FROM POLLY

Dyeing in volume is probably the most important aspect of my work. Each year fellow rug hookers Patty Yoder, Diane Kelly, and I invite noted colorist Maryanne Lincoln to spend a few days with us in Vermont. We are in the dye pots from early morning to late evening, and in that time I dye enough wool for most of that year's rugs. That cram session is probably the one part of my work I could not do without. While I'm there I not only learn about the colors I want, and learn to compensate for the colors in the vintage wool, but I do large amounts of dyeing without interruption. It's my life saver. The camaraderie is great, too.

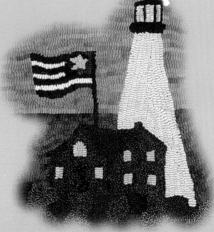

JULY

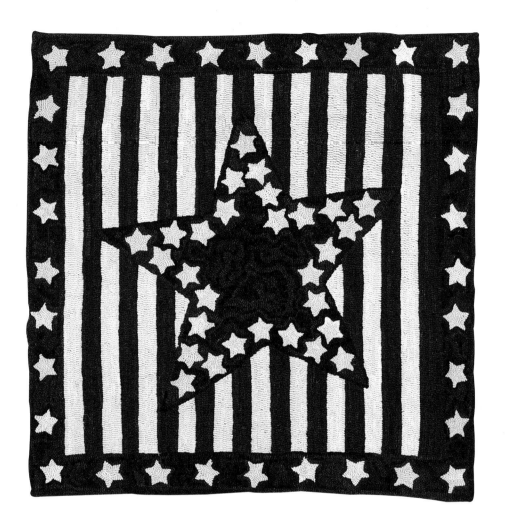

～～～～～～～

Stars on Stripes, 36" x 36", #8-cut wool on burlap.
Designed and hooked by Polly Minick, 1994. Artist's
private collection. Polly hooked two rugs with this
pattern, which was taken from a quilt made for her
by her sister, Laurie Simpson.

1

~~~~~~~~~~~~~~~~~~~~~~~~~~~~~~~~~

2

~~~~~~~~~~~~~~~~~~~~~~~~~~~~~~~~~

3

~~~~~~~~~~~~~~~~~~~~~~~~~~~~~~~~~

4 ★

~~~~~~~~~~~~~~~~~~~~~~~~~~~~~~~~~

5

~~~~~~~~~~~~~~~~~~~~~~~~~~~~~~~~~

6

~~~~~~~~~~~~~~~~~~~~~~~~~~~~~~~~~

7

8

~~~~~~~~~~~~~~~~~~~~~~~~~~~~~~~~~

9

~~~~~~~~~~~~~~~~~~~~~~~~~~~~~~~~~

10

~~~~~~~~~~~~~~~~~~~~~~~~~~~~~~~~~

11

~~~~~~~~~~~~~~~~~~~~~~~~~~~~~~~~~

12

~~~~~~~~~~~~~~~~~~~~~~~~~~~~~~~~~

13

~~~~~~~~~~~~~~~~~~~~~~~~~~~~~~~~~

14

JULY

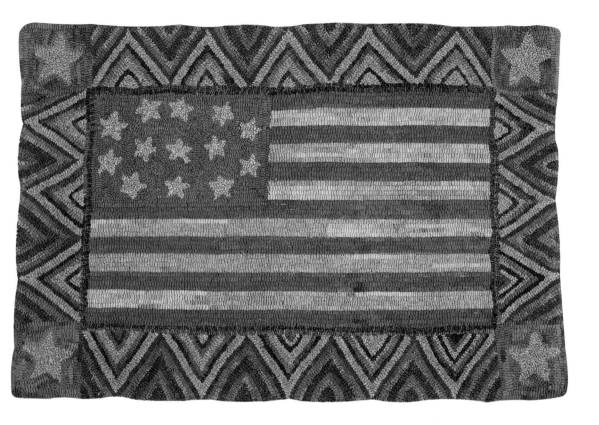

~~~~~~~~~~

Flag with Zigzag Border, 36" × 24",
#8-cut wool on burlap. Designed
and hooked by Polly Minick,
1995. Artist's private collection.
To visually link the border and
center of the rug, Polly used the
same colors in both and a star
motif in each of the border's
outer corners.

15

16

17

18

19

20

21

22

23

24

25

26

27

28

# JULY

**29**

**30**

**31**

## HOOKING HINTS FROM POLLY

Most people, if they take a minute to examine their work, will see that they have signature colors. I certainly do. The colors you will see in all my rugs are red, mustard, green, blue, khaki, and black. When I started working with Maryanne Lincoln, she worked out an exclusive chart for me. She realized that I don't use as many colors as most people, and that I use the same colors repeatedly, in different shades. Working with a specialist can wonderfully change your fiber art. It has allowed me to plan my dyeing and hooking time with exciting results.

# AUGUST

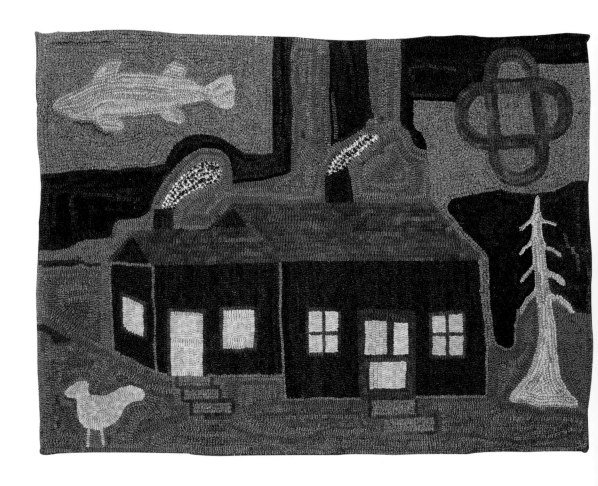

Nantucket Scene, 38" x 28", #8-cut wool on
burlap. Designed and hooked by Polly Minick,
1995. Artist's private collection.
The unusual symbols and house were drawn from
an anonymous piece dated 1885. Note the
black and cream check that forms the smoke
emanating from the chimneys.

1

_____

2

_____

3

_____

4

_____

5

_____

6

_____

7

8

_____

9

_____

10

_____

11

_____

12

_____

13

_____

14

# AUGUST

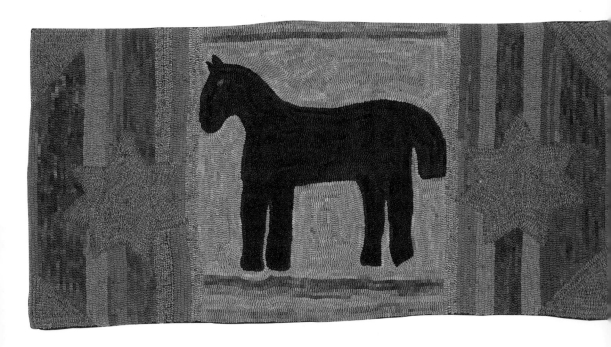

Red Horse on Blue Ground,
47" x 23", #8-cut wool on burlap.
Designed and hooked
by Polly Minick,
1995. Private collection.
A cut-out horse and stars reflect
Polly's love of primitive shapes and
simple rugs.

15

_____

16

_____

17

_____

18

_____

19

_____

20

_____

21

22

_____

23

_____

24

_____

25

_____

26

_____

27

_____

28

# AUGUST

| 29 | 31 |
|----|-----|
| 30 | |

## HOOKING HINTS FROM POLLY

I usually sketch an idea for a design as soon as it comes into my head. The weakest link in my art is my drawing skill. I keep the sketches until I have a few of them, then I meet with an artist friend and we go over the sketches so she can understand what I am after. She does a sketch based on mine and we refine it until it is what I had envisioned. I hire her to put the design on burlap for me.

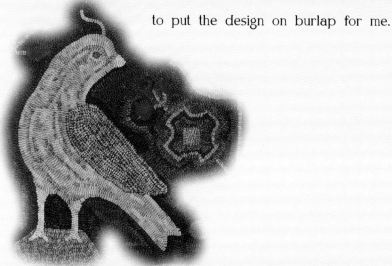

# SEPTEMBER

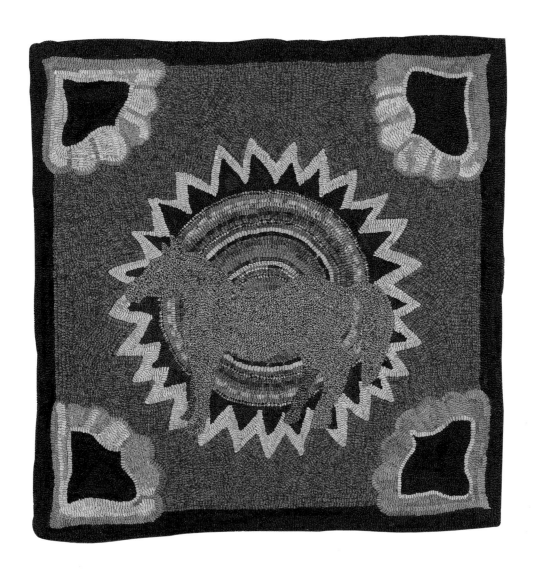

Sunburst Horse, 30" x 30", #8-cut wool on burlap.
Designed and hooked by Polly Minick,
1993. Artist's private collection.

1

2

3

4

5

6

7

8

9

10

11

12

13

14

# SEPTEMBER

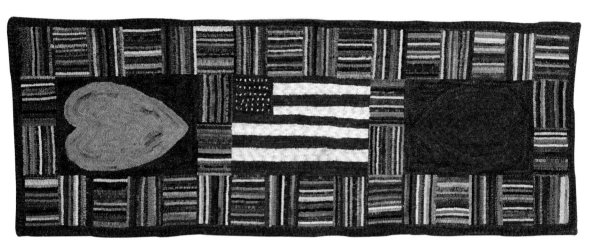

Two Hearts and Flag on Random
Ground, 80" x 20", #8-cut wool
on burlap. Designed and
hooked by Polly Minick,
1996. Artist's private collection.
A quilt-like background surrounds
the central motifs of this long,
narrow rug.

15

16

17

18

19

20

21

22

23

24

25

26

27

28

# SEPTEMBER

## HOOKING HINTS FROM POLLY

Over the years I have revised the order in which I go about hooking a rug. Lately, I have found that this procedure works well. After I have a design on burlap, I have binding tape sewn onto the back of the rug so I can hook right up to its edge. I plan the rug's colors by placing the burlap on the floor and pulling out colors from my wool supply. I leave the pattern and wool on the floor for several days so I can study the colors often. Once I've selected the colors, I hook about a third of the pattern to see if they really work well together, then I fold up the pattern with the chosen wool and put it on a shelf. When I get back to the rug, the burlap is drawn, the tape is sewn on, and the colors have been chosen, so I can finish it quickly.

# OCTOBER

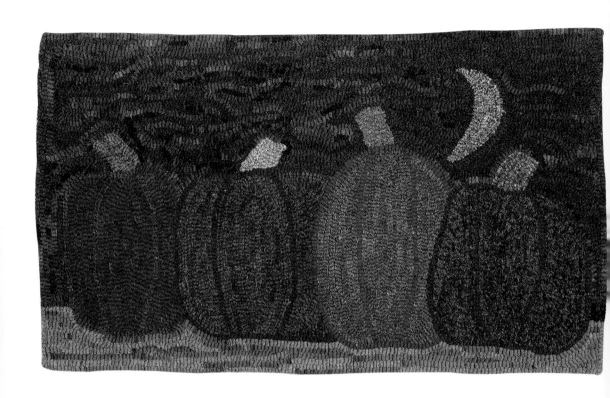

Pumpkins, 24" x 14", #8-cut wool on burlap.
Designed and hooked by Polly Minick, 1995. Private
collection. Polly's skillful dyeing of remnant wool is
obvious in this autumn scene.

1

2

3

4

5

6

7

8

9

10

11

12

13

14

# OCTOBER

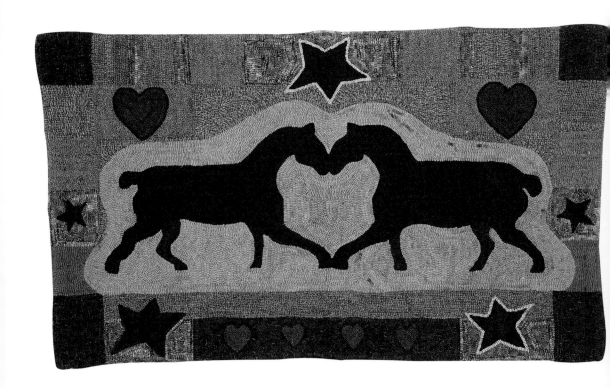

Logo Horses, 52" × 30", #8-cut
wool on burlap. Designed and
hooked by Polly Minick,
1993. Private collection of Dr. and
Mrs. T. Morris, Memphis, Tennessee.
Polly uses this design to represent
her rug hooking business.

15

16

17

18

19

20

21

22

23

24

25

26

27

28

# OCTOBER

29

31

30

## HOOKING HINTS FROM POLLY

Now the last step is here—the actual hooking. I find hooking

therapeutic. I think it is the easiest part of making a rug, so I

just enjoy the rhythm of pulling the loops up one by one until

strips of wool remnants and a simple

pattern on burlap become a beautiful rug.

# NOVEMBER

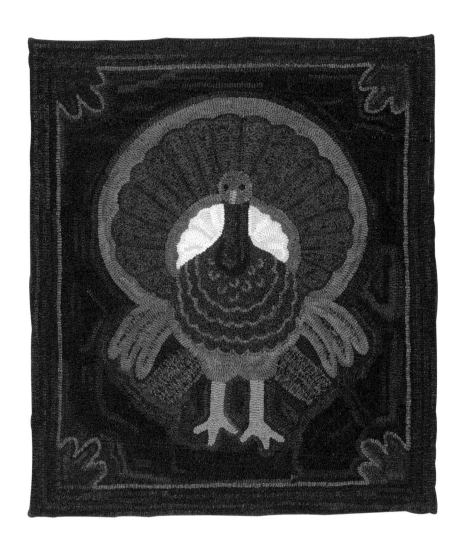

Tom, 26" x 30", #8-cut wool on burlap.
Designed by Emma Lou Lais. Hooked by Polly Minick,
1997. Private collection of Thomas and Allison Minick,
Annapolis, Maryland. Copyright © Emma Lou Lais.

1

2

3

4

5

6

7

8

9

10

11

12

13

14

# NOVEMBER

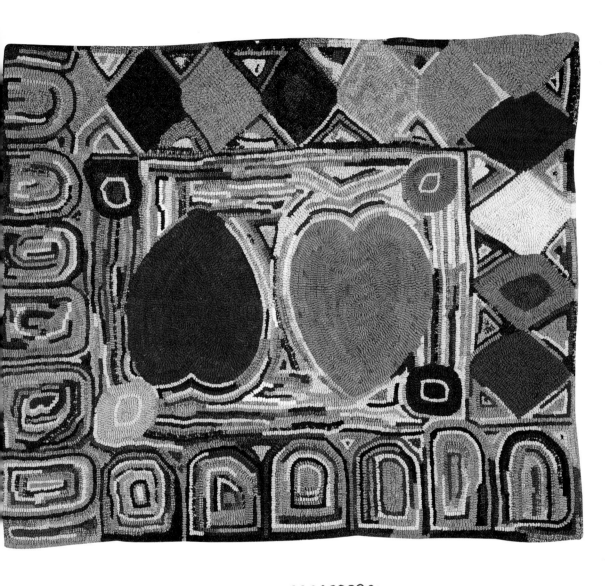

Two Hearts, 38" x 32", #8-cut wool on burlap.
Designed and hooked by Polly Minick,
1995. Private collection of Marcos Delgado and
Dale Turnipseed, New York, New York.
An antique rug, designer unknown,
inspired this piece.

15

16

17

18

19

20

21

22

23

24

25

26

27

28

# NOVEMBER

## HOOKING HINTS FROM POLLY

I use a quilting hoop to hook with instead of a rug hooking frame. I have tried using a frame, but it just doesn't work for me, because I hook so quickly and move the pattern so frequently that stopping to shift the rug in the frame would only slow me down. A hoop is also more portable, which is important to me since I hook everywhere I go. The quilting hoop I use has a long 4" bolt, so even the bulky hooked portion of a rug fits easily in the hoop.

# DECEMBER

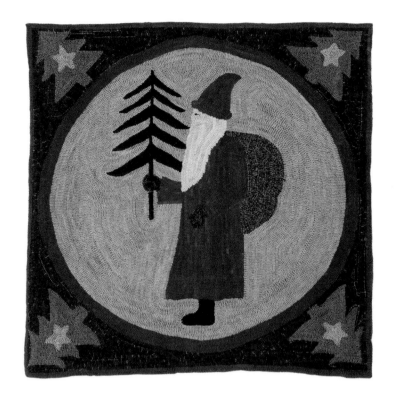

Santa, 36" × 36", #8-cut wool on burlap. Designed and hooked by Polly Minick, 1986.
Private collection of Ramsey and Patty Yoder, Tinmouth, Vermont. A Saint Nicholas from yesteryear is surrounded by a border of pine trees and Christmas stars.

1
_____

2
_____

3
_____

4
_____

5
_____

6
_____

7

8
_____

9
_____

10
_____

11
_____

12
_____

13
_____

14

# DECEMBER

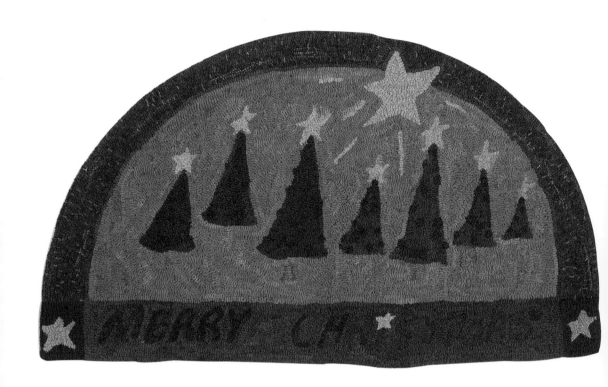

~~~~~~~~~~~~~~~~~~

Merry Christmas, 36" x 21", #8-cut wool on burlap.
Designed and hooked by Polly Minick,
1994. Private collection of Grant and Emily Kate
Minick, San Clemente, California.
Polly's signature stars take on a different
significance in this primitive portrayal of a stand of
decorated Christmas trees on a half-round rug.

15

16

17

18

19

20

21

22

23

24

25

26

27

28

DECEMBER

29	31
~~~~~~~~~~~~~~~~~~~~~~~	~~~~~~~~~~~~~~~~~~~~~~~
30	

## HOOKING HINTS FROM POLLY

Although most people hook in one direction only, usually from right to left, I hook in all directions, but mostly up and down. Being able to pull up the loops in any direction enables me to hook quickly. It also means I don't have to constantly turn the entire rug to hook one part of it.

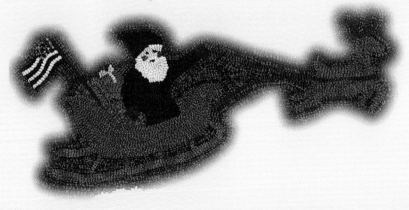

# WHAT IS RUG HOOKING?

Some strips of wool. A simple tool. A bit of burlap. How ingenious were the women and men of ages past to see how such humble household items could make such beautiful rugs.

Although some form of traditional rug hooking has existed for centuries, this fiber craft became a fiber art only in the last 150 years. The fundamental steps have remained the same: A pattern is drawn onto a foundation or backing such as burlap or linen. A zigzag line of stitches is sewed along the edges to keep them from fraying as the rug is worked. The foundation is stretched onto a frame, and narrow (2/32" to 8/32") strips of wool, which may have been dyed by hand, are pulled through to the front of the foundation with an implement that resembles a crochet hook stuck into a wooden handle. The compacted loops of wool remain in place without the need for knots or stitching. The completed rug may have its edges whipstitched with cording and yarn as a finishing touch to add durability.

Despite the simplicity of the basic method, highly intricate designs can be created. Using a multitude of dyeing techniques to produce unusual effects, various hooking methods to create realistic shading, and different widths of wool to achieve a primitive or formal style, today's rug hookers have gone beyond the strictly utilitarian, home-based use of hooked rugs to make wallhangings, vests, lampshades, bell pulls, purses, pictorials, portraits, and more. Some have incorporated other kinds of needlework into their hooked rugs to fashion unique and fascinating fiber art that's been shown in museums, exhibits, and galleries throughout the world.

The rugs seen in this book of days are primitive in style and were hooked with a wide (1/4") cut of wool. This style is but one of the many employed by the thousands of rug hookers worldwide. For a good look at what contemporary rug hookers are doing with yesteryear's craft—or to learn how to hook your own rug—pick up a copy of *Rug Hooking* magazine, or visit our web site at www.rughookingonline.com. (To learn more about *Rug Hooking* magazine, see page 64.) Within the world of rug hooking—and *Rug Hooking* magazine—you'll find there's a style to suit every taste and a growing community of giving, gracious fiber artists who would welcome you to their gatherings.—*Patrice Crowley*

 Continued from page 2

# A WORD ABOUT *RUG HOOKING* MAGAZINE

*Rug Hooking* magazine, the publisher of *A Rug Hooking Book of Days*, welcomes you to the rug hooking community. Since 1989 *Rug Hooking* has served thousands of rug hookers around the world with its instructional, illustrated articles on hooking techniques, dyeing, designing, color planning, and more. Color photographs of beautiful rugs old and new, profiles of teachers, designers, and fellow rug hookers, and announcements of workshops, exhibits, and gatherings appear in each issue.

*Rug Hooking* has responded to its readers' demand for more inspiration and information by going online, publishing pattern books, revising its *Sourcebook* listing of teachers, guilds, and schools, and continuing to produce the competition-based book series *A Celebration of Hand-Hooked Rugs*. This book of days represents but a fragment of the incredible art that is being produced today by women and men of all ages.

For more information on rug hooking and *Rug Hooking* magazine, call or write us at the address on page 1.

# WHERE TO BUY THESE RUGS

Polly's rugs are not available as patterns. Her rugs, however, are for sale through Barton-Sharpe Ltd., 66 Crosby Street, New York, NY 10012, (212) 925-9562.

The rugs designed by Edyth O'Neill (*Bird and Pomegranates* and *Ohio Coverlet*) are available as patterns printed on foundation material through Joan Moshimer's Rug Hooker Studio. P. O. Box 351, Kennebunkport, ME 04046-0351, (800) 626-7847.

The rugs designed by Emma Lou Lais (*Melting Snowmen* and *Tom*) are available as patterns printed on burlap or monk's cloth. Write or call Emma Lou Lais, 8643 Hiawatha Road, Kansas City, MO 64114, (816) 444-1777.

You can get in touch with Polly at 920 Champney, St. Simons Island, GA 31522, (912) 638-0255.